THE AESTHETIC OBSESSION

Also by Lyall Wilkes

TYNESIDE CLASSICAL
The Newcastle of Grainger, Dobson and Clayton
(with Gordon Dodds)

TYNESIDE PORTRAITS
Studies in Art and Life

JOHN DOBSON, Architect and
Landscape Gardener

SOUTH AND NORTH and other Poems

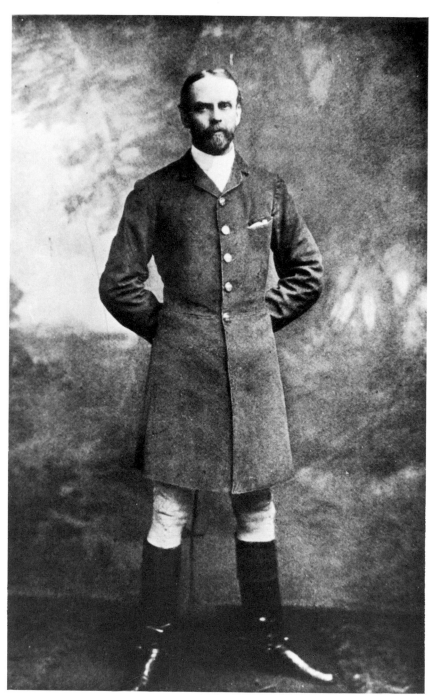

SIR WILLIAM EDEN, Bt.

THE AESTHETIC OBSESSION

A Portrait of Sir William Eden Bt.

by

LYALL WILKES

ORIEL PRESS

STOCKSFIELD

BOSTON · HENLEY · LONDON

First published in 1985
by Oriel Press Limited
Stocksfield, Northumberland,
England, NE43 7NA.
14 Leicester Square,
London WC2H 7PH.
3 Park Street, Boston,
Mass. 02108, U.S.A.

Set in Times New Roman and
printed by Hindson & Co. Ltd.,
Newcastle upon Tyne

Colour separations by
Philipson Burrill Limited
Newcastle upon Tyne

Trade enquiries to
Routledge & Kegan Paul PLC
Broadway House, Newtown Road,
Henley-on-Thames, Oxon. RG9 1EN.

ISBN 0 85362 222 1

FOR

SERENA JAMES

LIST OF ILLUSTRATIONS

Monochrome

Sir William Eden Bt.	*Frontispiece*
Windlestone Hall	page 5
Windlestone Hall	6
Sir Robert Eden	7
An enclosure in the garden at Windlestone	13
The Stable Clock Tower	14
Lady Eden, portrait by von Herkomer	17
Sir William Eden in 1881	18
George Moore by Sickert	25
Sir William Eden by Max Beerbohm	26
The East Sitting Room at Windlestone	29
The Marble Table	30
Whistler by Bernard Partridge	33
The Baronet and the Butterfly by Max Beerbohm	34
Study in Brown and Gold	41
Wynyard by Carmichael	42
Teresa, Lady Londonderry	45
Wynyard	46

Colour Reproductions of Sir William's Watercolours

The Countess of Scarborough	49
The Japanese Cabinet	50
Still life with portrait of a lady	50
The Rose Window	50
The Garden, Windlestone	51
Sir William's desk	51
Corner of the Library at Windlestone	52
St. Paul's Cathedral	52
Buckingham Palace	52

Monochrome

Photograph of Sir William and friends	53
Windlestone, 1904 by George Thomson	54
At the Cavendish Hotel	65
The First Earl of Avon by Xavier Knapp	66
Sir Timothy Eden	71
Sir Willian Eden by Prince Paul Troubetzkoy	72

ACKNOWLEDGEMENTS

This is as impressionist a picture of Sir William Eden and his age as Sir William ever painted. It is also a picture of that Society at its most mysterious and fascinating moment, – caught just as it slips away for ever beyond living memory. I have been particularly fortunate to have been able to talk to people like Lady Serena James whose husband, Bobby James, created a famous garden, still much visited, at St. Nicholas near Richmond in North Yorkshire. He knew Sir William well as a fellow connoisseur of gardens and gardening. Lady Serena, who still carries on the garden, has kindly given me permission to reproduce in this book watercolours given to her by Sir William, including one of her mother, Celia, Countess of Scarborough.

I am also grateful to have been able to exchange letters with Mrs Evelyne Hastings-Ord who remembers as a little girl being allowed to sit with Sir William while he painted.

This book also draws on Sir William's correspondence with Theresa, Lady Londonderry, his intimate friend and near neighbour at Wynyard, known to both Sir William and his wife Sybil as "Nelly". I should like to express my thanks to Mr K. Hall, the Durham County Archivist for extracting these letters from the Londonderry Papers in his archives. Thanks are also due to Sir Rupert Hart Davis as publisher and editor of *Letters to Reggie Turner*, for permission to quote from Max Beerbohm's letter describing his stay at Windlestone in 1898 and also for permission to reproduce the Beerbohm caricatures of Sir William from collections which Sir Rupert has edited and published.

The present Marquess of Londonderry has kindly allowed me to reproduce the photograph of Sir William with the 6th Viscount Londonderry at Wynyard Park in September 1890 taken from *The Londonderry Album* which he has written and annotated. My thanks go also to Sir Brinsley Ford who drew my attention to *The Letters of Richard Ford* (John Murray 1905) in which light is thrown on Sir William's father's picture collecting exploits in Spain.

I am grateful to the Hon. Mrs Daphne Fielding for permission to quote from two letters from Sir William to Rosa Lewis of the Cavendish Hotel, set out in her book *The Duchess of Jermyn Street*, as well as for allowing me to use the photograph, given to her by Rosa, of Sir William standing in front of the Cavendish in 1912; and to H. Montgomery Hyde Esq. I am indebted for my being able to use the portrait of Theresa, Lady Londonderry from his collection.

To Mrs Lilian von Versen and to Mrs Rose Murray, Literary Executors of Sir Timothy Eden, and to the Countess of Avon and the Earl of Avon, the Literary Executors of the 1st Earl of Avon, I am pleased to record my obligation and thanks for permission to quote from two books that deserve to live – Timothy Eden's *The Tribulations of a Baronet* (Macmillan, 1933) and Anthony Eden's *Another World* (Allen Lane, 1976). Miss Lilian von Versen and Mrs Rose Murray have also given me permission to quote from Sir Timothy's two volume *Portrait of Durham County*, published by Robert Hale, the best modern description of a county that I know.

To Mr Peyton Skipworth of The Fine Art Society, Mr Humphrey Potts Q.C., His Honour Judge Oliver Wrightson, Mr Wilkie Willis and Mr Michael Holroyd I must express my gratitude for information and assistance.

The captions on the illustrations in this book show how much I owe to Sir William's two grandsons – Lord Eden of Winton, the head of the Eden family, and the Earl of Avon – for allowing me to reproduce pictures by Sir William in their possession and their never failing courtesy and patience in answering my questions. Lord Eden also helped me to trace the

few fragile survivors who had known Sir William. Finally to the Countess of Avon I must express my thanks for also permitting me to reproduce some of Sir William's watercolours from her collection.

Lyall Wilkes
Dissington, 1985

THE AESTHETIC OBSESSION
A Portrait of Sir William Eden Bt.

I

In any gallery of 19th Century eccentric aristocratic achievement three Baronets stand out in their tragically unconscious comicality – Sir Walter Blackett, Sir George Sitwell, and Sir William Eden. It was said of Sir Walter Blackett, that melancholy mineralogist from Wallington, a hypochondriac who rarely smiled, that by the age of thirty-six "His emotions had begun to resemble the fossils to which he was so devoted".[1] A Temperance fanatic, he frequently threatened to throw the contents of the best cellar in Northumberland into the River Wansbeck and did the next best thing by leaving every bottle to Dr B. W. Richardson, his brother in temperance agitation, to be employed – as his will put it – "for scientific purposes".[1] He died, as every good hypochondriac should, after an illness of one day in his eighty-third year in the middle of dealing with the morning's post, having claimed to the mystification of his doctor on the previous day that tumours were forming on his lungs.

Sir William Eden had more in common with Sir George Sitwell of Renshaw and Montegufoni – indeed their lives and fate ran on strangely parallel lines; both were life-long devotees in search of a perfect beauty in art and life through gardens, painting and architecture and both achieved much; yet both lived with a sense of failure and both were overwhelmed not infrequently by rages which showed that judgment and a sense of proportion do not necessarily accompany even rare intelligence. In the end both were convinced of betrayal by family, friends, and by life itself, and died despairing and isolated.

Sir William Eden, born 4th April 1849, 7th Baronet of West Auckland (created 1672) and 5th Baronet of Maryland (created 1776) late Lieutenant 8th Hussars, was a slim waisted straight-

backed man of superb physique over 6 feet tall and immensely strong. He had red cheeks, bright blue eyes, a reddish brown beard and moustache, and as he grew older his tufted and upward sweeping eyebrows grew increasingly melodramatic. Taught to box by the famous Bat Mullins who said he was the best amateur he had ever trained, every morning he was furiously at his punchball. He boasted there was no man in the North Country he could not flatten. Bombardier Billy Wells, who became the British Heavyweight Champion was an honoured guest at Windlestone, the Eden seat, often staying for weekends to spar with Sir William and with any other guest or estate worker who fancied his chances. Eden was the outstanding athlete amongst the Durham and North Yorkshire gentry, his acknowledged leadership in the County owing as much to his physical prowess as to his 8000 acres.

He was a legendary Master of the South Durham Hounds for nine years during the 80's and 90's, and even as late as the nineteen thirties was still talked of in Hunt circles as the best and bravest Master the South Durham had ever had. The Windlestone stables were full of hunters and steeplechasers, some of which he had trained and ridden himself to win at Sedgefield and Catterick Bridge and Wetherby. One of the best shots in England, a member of his shooting party at one of his famous three day shoots at Windlestone, once counted him cleanly killing 38 out of 40 high flying pheasants.

Yet this was the man who had such a love and understanding of art that in 1893 George Moore dedicated his book *Modern Painters* to him; who exhibited his watercolours at almost every exhibition of the New English Art Club between 1896 and 1909, whose work was shown at the Paris Salon; who was collecting works by Corot, Dégas, Renoir, Fantin-Latour, Whistler and Sickert, when most Englishmen were still collecting Birkett Fosters – if they collected anything at all. This was also the man whose work was given highly praised "One Man" shows in London Galleries such as The Goupil Gallery and Colnaghi's, and for whose catalogues Sickert and George Moore wrote introductions. His watercolours generally

were deemed by critics to be second only to those of Hercules Brabazon Brabazon, of all those English artists who were "amateurs" only in the sense that they did not paint to earn a living.

There was another sphere in which in the late nineteenth and early twentieth century he stood almost alone. This was in his theory and practice of the aesthetics of gardening. His vituperative campaigns (often conducted through articles and letters in the Saturday Review), against indiscriminate and shrieking colour and his plea for related and muted tones, even for gardens without flowers, – architecturally shaped trees, stonework and statuary taking their place – acknowledged the influence of classicism and the Italian garden and were concepts opposed to the prevailing suburban gardening fashion. Only the fact that he spent so much of his time painting and not writing prevented him, (unlike Sir George Sitwell), from writing the book which would have won him wider recognition as an authority on gardening as landscape.

It must be apparent already that rarely, if ever, had one physical frame contained two such violently contrasting natures – the superabundant energy and hardness of the exultant physical man opposed to the sensitivity and perception of the artist. The strain which such a contradiction imposed on a man whose nature brooked no contradiction often brought him to breaking point and explosion, as his son Sir Timothy Eden described [3].

> He was a true and loyal friend, a shrewd adviser with a knowledge of the world, a man largely capable of sympathy and love, and sadly needing it: but his uncontrolled rages terrified and drove away an approaching friendship as a bird is scared to a distant branch. His intolerance of the opinions of others not only hurt their natural vanity but made any reasonable discussion impossible. His personal and direct rudeness was offensive to the most patient. His constant and exaggerated irritation with the minor details of life, and the volcanic expression which he gave to his acute

suffering from incidental noises, sights and smells – mere nothings which the normal man passes over unnoticed ----. It is not easy to understand how a terrible tornado of oaths, screams, gesticulations and flying sticks can be seriously prompted by a barking dog; nor will anyone readily admit that the whistling of a boy in the street can be a good and sufficient reason for breaking a window with a flower pot.

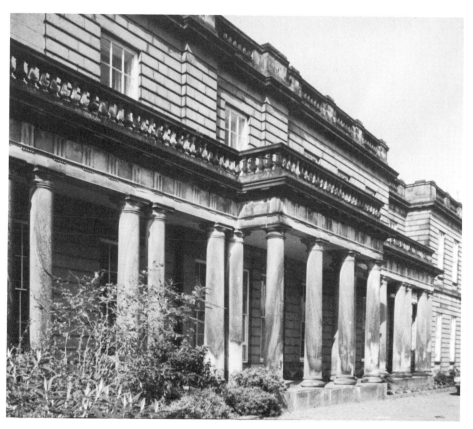

WINDLESTONE HALL
The long colonnaded Loggia Front

Photograph by Ursula Clark

WINDLESTONE HALL
From the Garden

Photograph by Ursula Clark

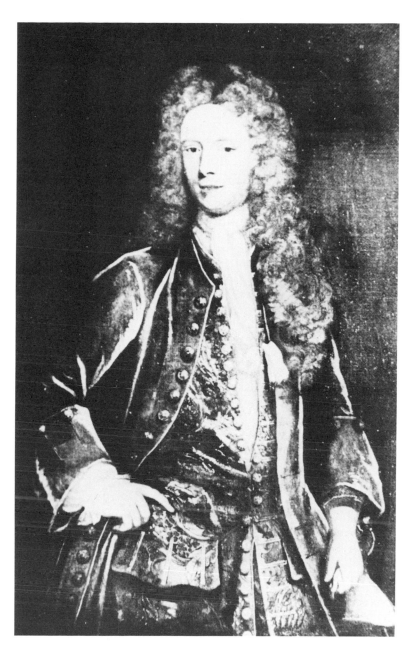

SIR ROBERT EDEN
(1644—1721)
The first Baronet of West Auckland

SIR ROBERT EDEN, Bt.

A note in the Diary of Samuel Pepys, dated April 7th, 1669, relates to Robert Eden, a barrister of the Temple, who only three years later became Sir Robert Eden, the first Baronet of West Auckland. He married Margaret Lambton a near neighbour in County Durham. Eventually they had fifteen children but Pepys describes an incident during their courtship . . .

> *Thence . . . to Talbot's Chamber at the Temple . . . and hither come Mr Eden who was in his mistress's disfavour ever since the other night that he come in thither fuddled, when we were there. But I did make them friends by my buffoonery and bringing up a way of spelling their names, and making Theophila spell Lamton which The. would have to be the name of Mr Eden's mistress, and mighty merry we were till late.*

Sir Robert Eden represented County Durham in seven parliaments. He married the lady here alluded to, Margaret, daughter and heir of John Lambton.

II

The Eden Baronetcy of West Auckland owed its creation to Charles II's determination not to revive the hatreds of the Civil War which might send him on his travels again. Therefore on his restoration in 1660 he did not honour those men who had helped his father during the wars, but thought it more politic to reward, after tactful intervals, the eldest sons of some of his father's former supporters. No recognition was therefore given to John Eden of West Auckland and Windlestone who had raised a regiment of 1,000 Foot for the King's cause, had been Colonel of it and seen his estates forfeited in consequence. Instead, his son Robert, a Barrister of the Temple who is mentioned by Pepys in his diary entry for April 7th 1669 was made the 1st Baronet of West Auckland in 1672 whilst his father, the old Colonel, lived on until 1675 and died a Commoner.

Although a descendant of the de Edens, a family first heard of in the records of the 12th Century at Preston on Tees, Sir William was no snob. Indeed nothing excited him to disgust more violently than the pretensions and hypocrisies of his own class. Essentially kind and warm hearted, he had an instinctive understanding and sympathy for the working man and his processes of thought were as simple and direct as theirs. Indeed he romanticised them as in a letter to an old servant.[4]

> There are no honest people or gentlemen in the upper classes but you may find them amongst workpeople and occasionally bourgeois ---- I have seen as good manners in a prize fighter as in a pedagogue – and better; and best of all in a Highland ghillie.

In spite of his dancing hornpipes of rage, his stick-smashing of the glass houses when the contents displeased him, he was idolised by his workpeople because of his straightness, lack of

affectation and honesty. Even his worst hornpipes were punctuated by jokes and insights into his servant's position and when he realised he had gone too far he would mollify, charm, make them gifts and even apologise. Some of his employees, such as his long suffering valet Woolger, – (who told him he needed a keeper not valet) – had been sacked a dozen times, but were still with him when he died.

His absolute honesty was the basis of his atheism for he was incapable of hiding his real thoughts and feelings that no God worthy of respect would allow the cruelties and miseries of the world, which were torture to him, to happen, and no merciful God, he said, "would want to inflict a second life on even the worst sinner". His humour was satanic – "a thing of beauty is a pain for ever".[5]

"Do we shoot hens Willie?"

"Yes" shouted Willie, "shoot hens, shoot everything, shoot the Holy Ghost if he comes out."

A morbid streak in him made him prefer suffering to laughter. "I have heard a person – I think it was a woman – laugh at a masterpiece by Dégas. I have seen and heard others laugh at cruelty and suffering -- NO! it is very seldom that happiness is refined or pleasant to see. Perhaps that is why the best of everything is produced by or in suffering and it has always been so ---- are not the pictures of Velasquez and Millet the embodiment of experience, thought and pain? -- Pain is horrible but it is almost justified by its beauty".[6] He wrote to a woman friend "Every feeling, thinking person is sad. I am sad because I suffer torture from my imaginations." "Life to the sensitive is a great and terrible affliction".[7]

He ordered his sons Timothy and Anthony to walk as if they had "just bought the earth", and with a fortune at his disposal sufficient to gratify every wish, that is how he himself walked, with despair gathering about his heart. "I have missed doing anything well and have succeeded only in failing at everything".

III

Sir William's passion for art did not make him a cuckoo in the nest in the Eden family tree. In addition to the Governor-Generals, the Ambassadors, Bishops, Peers, Ministers of State, Admirals and Generals arising throughout four centuries in almost every generation of this extraordinarily gifted family, from time to time less conventional spirits emerged. When the wife of the fourth baronet died in 1766 the husband adapted Pope's "Elegy to the Memory of an Unfortunate Lady" to his own purpose in bidding her a bitter farewell, anticipating by over one hundred years Sir William's own iconoclastic non-belief -

How lov'd, how valued once, avails thee not,
to whom related, or by whom begot;
a heap of dust alone remains of thee
'Tis all thou art, and all the proud shall be.

There was Emily Eden author of "Portraits of the People and Princes of India" (1844) whose two novels "The Semi-Detached House" (1859), and the "Semi-Attached Couple", (1860) achieved a good measure of Jane Austen's irony and success. She too had a notable talent for drawing and watercolour as the drawings which accompanied the publication in 1866 of *Up the Country* showed. This was a selection of letters to her younger sister Fanny written from India whilst Emily was either staying with her brother, the disastrous second Lord Auckland, the Governor-General, or travelling with him in remote regions. Emily lived on until 1861 and Eden Lodge, Upper Gore Kensington, became a noted literary salon whose receptions were always held in the morning, since she maintained, against all visible evidence, that her health would not allow of evening receptions. She died in 1869 at the age of 72. Her eldest sister Eleanor, "the first and only love of William Pitt", had died in 1851.[8]

There was Sir William's own grandfather, Sir Frederick Morton Eden who died in 1809, the author of a pioneering and monumental work, "The State of the Poor", a work highly praised by Marx who wrote "Eden is the only disciple of Adam Smith during the eighteenth century who produced any work of importance."[9]. His fourth son, Lt. General George Morton Eden, was a skilled watercolourist who had studied under Peter de Wint[10]. But the most powerful influence on the mind of the young Sir William, apart from Windlestone itself, were the early Spanish paintings collected in the course of prolonged travels in Spain by his father (Sir William, the 6th Baronet of West Auckland, and the 4th of Maryland) with Richard "Spanish" Ford, author of the famous *Handbook for Spain*, published in 1832, which he dedicated to Sir William "In Memory of Happy Days spent in Beloved Spain". This Sir William had succeeded to both Baronetcies in 1844 through his uncle, the builder of Windlestone, and was no less a remarkable collector and connoisseur than his son was to become, if less of an artist.

A letter from Seville from Ford[11] dated January 11th 1832 to Henry Addington, Envoy Extraordinary and Plenipotentiary at the Court of Madrid, casts some light on Eden's picture buying -

> We are all crazy here about pictures, such buying and selling ---- the market will be cleaned out. Sir William Eden is Muy Pegajoso and Bizarro (very attractive and full of spirits). I did not suspect that he was such an amateur and collector. In short, we are buying things here at double what they are worth in England.

This was the origin of Windlestone's fine collection of Spanish paintings, including a Murillo and a Franceso de Ribalta, surprising discoveries in a Durham Squire's house in the 1860's and 70's. There were paintings also from the Dutch and Italian schools including a Carel Fabritius now in the National Gallery, a Guercino, a Paul Veronese, and others in sufficient number to enable the walls of Windlestone to escape the characteristic English painting of the mid-Victorian period.

WINDLESTONE HALL
An Enclosure in the Garden

The Gardens of England, Studio 1911

WINDLESTONE HALL
The Stable Clock Tower

Photograph by Ursula Clark

The Windlestone in which these paintings were hung, and in which the subject of this study grew up, was a neo-classical house designed by Ignatius Bonomi in 1834 and built in sandstone to the order of Sir William's uncle – Sir Robert Johnson Eden – a wealthy bibliophile bachelor at a cost of £80,000. It was built on rising ground from which it enjoyed extensive views of a part of Durham County, then still beautifully wooded and unscarred. Into this Paradisal scene extended a long colonnaded front with coupled Tuscan columns, much horizontal rustication, a highly decorated balustrade at roof level spaced with classical urns, a clock tower with more Tuscan columns, and the simple classical mausoleum (no Gothic horror of the period), built by Sir William's father to the memory of the six of his eleven children, who died in infancy.

This was the beautiful house and landscape to which Sir William succeeded at the age of twenty four in 1873 and on the embellishment of which he was, as a way of life, to devote his energy and fortune.

IV

In 1886 Sir William married the beautiful Sybil Grey, after thirteen years of transforming Windlestone to his own taste, and one suspects that this decision, (like almost every other decision he took) was primarily an aesthetic one to crown his work. He loved the beauty of his wife to his dying day and delighted in showing her off to embarrassed friends in her presence – "have you ever seen anything more beautiful?". Her father, Lieutenant Governor of Bengal and later Governor of Jamacia, was a grandson of the first Earl Grey of the Reform Bill. She was, therefore, a cousin of Grey of Falloden, Britain's Foreign Secretary at the outbreak of the 1914 war. Sir William, after a few years of wary truce, showed little sympathy or liking for the urbane and conciliatory Greys and was roused to such near apoplexy by his wife's brother Robin, that he refused to support his prospective Parliamentary candidature in his Durham Constituency. To Theresa Lady Londonderry he writes about Robin's candidature, the writing growing larger and wilder as his anger rises into allegations of "treachery" and "deceit" about some trumpery matter.

> You see, dear Lady, I cannot support a man who is not a gentleman and who is a fool – and as I never do things by half, I shall oppose him.

Sybil, Lady Eden, was kind and much beloved and therefore sometimes became the victim of presumption in others. Lady Serena James has told how a very rich lady, a Mrs Hunter, whom Lady Eden had never met, began her letter -

> Dear Sybil, I hope you will forgive me for addressing you as Sybil because that is how I always think of you.

Sir William was outraged. "You must write her", he said "and ask to be forgiven for addressing her as Mrs Hunter because that is how you always think of her",

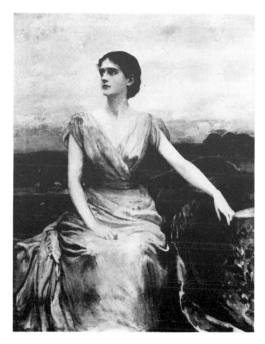

LADY EDEN
A portrait by Sir Hubert von Herkomer

By permission of Lord Eden of Winton

SIR WILLIAM EDEN, 1881

BBC Hulton Picture Library

The Windlestone estate was not so much farmed by Sir William as composed. His aim was beautification rather than profit. The trees were chosen by him and planted not from the point of view of their value when cropped, but to give a painter's point and emphasis to a landscape and for their spring and autumn colour. It was the same with the deliberate restraint and restricted colours of his herbaceous borders – his favourite colour was blue with all its variations in shade; pink, grey, white and silver were permissible as was purple, but not yellow except for his horse carriages and motor cars and for the walls of his study against which he hung his "immaculate Dégas" of the two washerwomen. Red was never permitted for any purpose whatsoever. The only colour allowed on estate houses was blue. In fact he planted and designed his estate for the effects he liked to paint.

And he liked theatrical effects, inside as well as outside the house, and produced them like a theatrical producer – which in a sense he was. Determined to find the best background for his pictures he had the dining room repainted in his favourite blue, and had the red flock wallpaper in the East Hall overpainted in black, to produce a "strangely glowing and splendid effect"[12] for the early Dutch paintings in their elaborate Jacobean frames. The salon, furnished with choice 18th Century furniture, down to which the fine central staircase led, was lit from a glass dome in the roof, and had a deep plaster cornice consisting of a classical frieze based on the Elgin marbles and the figures on the Parthenon. A representative from Hatchards the booksellers came up from London each year to advise on additions and replacements for the library. Throughout the house, paintings of the highest quality from all periods and schools lived comfortably side by side.

Anthony Eden (The 1st Earl of Avon), the second surviving son of Sir William, summed it all up:[13]

> By the time I was conscious of my surroundings he had made it into something rich and rare ---- more even than in his watercolour painting my father had created Windlestone as only an artist could, as a personal

harmony. ---- My father built the terraces which set off Bonomi's architecture and, above all, thinned and planted at every angle from the house, until the trees were Windlestone's chief glory. It was the same within the house. Apart from pictures and furniture, the decoration, the curtains, the library kept up to date, all these taught, beguiled, even inspired any visitor in the least sensitive to beauty.

The Eden family motto *Nullum Numen Abest Si Sit Prudentia* (Heaven will favour us, provided we be prudent) was not for Sir William. His God – if an aetheist may be permitted a God which he should be – lay not in prudence but in the worship of truth and beauty in the creation of artistic perfection. The reverse side of this was his deeply felt anguish and anger that the "progress" he so loathed was bringing so much ugliness as the twentieth century approached, and as the yellow phaetons and broughams were being replaced by the two yellow Benz, the yellow Siddeley and the yellow Napier. In the meantime the house was full of a company of carefully chosen guests almost every weekend, there were hunting and shooting parties throughout Autumn and Winter over which he presided as the perfect (if brittle-tempered) host, enjoying perfect food under his perfect paintings; it was, save for the knowledge that he was grossly overspending, the nearest thing to human felicity he would ever achieve.

V

For a man of such strongly individual tastes and childish egotism, so easily excited to irritation and disgust by so many sights, sounds and smells – dogs in a small house, children in a house of any size, whistling, bridge, tennis parties, bedding out, the smell of tobacco, Americans, strident colours in a garden, sunsets in and out of picture frames, and 19th century Gothic architecture – he was never at ease in other peoples' homes or with other peoples' tastes. He wrote[14] to a friend who had mistakingly procured him an invitation for a week-end visit ---- "I really can't, it's not affectation, stand these sort of surroundings. Crimson ramblers and calceolarias against a red-brick house – all of them framed in self-satisfaction". Nor could he forgive Sussex[15] "with its red houses in rows, under the custody of puzzle-monkeys; with its vulgar rhododendrons on guard amongst their dirty leaves, entirely out of value with the vitriol green of verdant spring; with copper beeches coming into leaf and laburnums heaping up the score, and a border in the distance of mangy Scotch firs".

Yet he was adjudged a kindly man even by some members of the hated tribe of childhood; but Mrs Hastings-Ord, was forgiven her's only because she was striving to become an artist. She still remembers how he would say "Come, sit with me" and recalls – "I used to sit with him for hours while he painted in the house and in his lovely garden or at my home, and he liked silence except for his explanations of what he was doing ----- I only saw the nice kind side of him. I never saw him cross or irritable, he was always helpful and gentle. He wrote me long letters about my painting and how to do it. I am very sorry I did not keep them. Of course I heard about his temper and the odd things he did, but in my childish way I thought a bit of it was just 'showing off', as I knew he liked to be different and to be admired and talked about.

His father was eccentric too. My father told me he used to ask him to sit with him and he found him – when he had coal by the ton – sitting with one candle by a miserable little fire wrapped in a rug, which he kindly shared with my father."

As Sir William aged so his rages grew. A gardener in whose greenhouse a red flower had been found by Sir William was astonished to see him on his knees on the floor of the greenhouse loudly cursing and praying for the offending gardener to be stricken down by the God he had so often denied; but one senses here the element of self-parody that was rarely very far below the surface of Sir William's explosions. These rages, which cost him his reputation as a man of seriousness and weight, were shortlived; within minutes the storm subsided and a bitter irony would prevail over the stricken greenhouse or drawingroom. Sir William had a rare talent for satire but his most successful and ultimately fatal subject for satire was himself.

His hatred of the debased Victorian Gothic architecture of his day ran as deep as his love for the true Gothic in Venice and France. The passing years did not diminish his rages (often expressed with much raising of stick and voice in front of the offending building itself), against the quintessential horror of the Albert Memorial – an affront to every rule of proportion and reason, and hence ultimately, to him, a moral affront.

As the new century drew near he came to regard Windlestone as his only defence against the growing ugliness of the outside world. It became a fortress and one which he felt was besieged. Here he entertained Max Beerbohm, Mrs Pat Campbell,* Walter Sickert, George Moore[16] and many others. Both Sickert and Moore admired his painting and wrote praising it in the Art Reviews. Uneasily straddling the three worlds of Sport, Society, and Art he was encouraged by their support and the unqualified praise which the London

*This friendship not only guaranteed seats at Mrs Campbell's performances for Timothy and Anthony when in London on their way to and from Eton, but led Sir William to persuade his wife to lend their French governess to Mrs Campbell for two weeks to improve her French for the 1904 production of Maeterlinck's *Pelleas*

exhibitions of his work at the Royal Institute Galleries, Colnaghi's, The Dudley Gallery, and The New English Art Club, received from the critics of the Morning Post, The Athanaeum, the Daily Telegraph and the Saturday Review.

Moore wrote[17]

> Sir William Eden is an amateur; we use the word in its original sense, and can conceive therefore no higher epithet of commendation. There are too few amateurs among us ---- a glance at the pictures show us that he is a painter who travels rather that a traveller who paints ---- How many watercolour artists are there living who need hesitate to sign that tall drawing, some eight inches in height by four in width, representing a narrow jutting street with an awning under which some turbaned figures are sitting? There is no sky above the street, the picture is without violent relief, a pink and a grey note blended and harmonised and united with refinement and skill. Examine the few lines that appear. Are they not seen with feeling, and are they not feelingly rendered and is there not the unmistakable beauty of touch of the born artist – of the amateur?

It can be seen, even from this, how faithful in his watercolours Sir William remained to the colours he chose for his garden.

His friendship with Moore, (that master of artifice wrote to Lady Eden, "he amuses me more than anyone – his artless naturalness tickles me"), was not untroubled. It was especially ruffled by Moore's confession that he preferred shooting rabbit to deer; but it survived even Moore's dissuasion at lunch in Paris from his buying several paintings by an artist new to Sir William whose work had so impressed him that very morning that he had reserved four. Telling Moore this at lunch Moore was not impressed. "My dear Sir William" he said, "you have

and Melisande, with Sarah Bernhardt playing Pelleas and Mrs Pat Campbell, with some trepidation, playing Melisande in French. Mrs Pat Campbell's visits to Windlestone so fascinated Timothy that after the war the young Baronet became a member of her touring company and played in Godfrey Tearles's London production of *Hamlet.*

your Dégas, you have your Corot; why bother with this fellow? If you want to buy a picture buy another Dégas". Overpersuaded, Sir William returned to the gallery after lunch and cancelled his reservations. The painter's name was Cézanne.

This incident shows Sir William's deference to Moore as critic; and whilst in return for Moore's public support for his own work he could assist Moore's strange ambition to pose as a 'toff' by putting him up for Boodles (one of Sir William's several London clubs), yet he made it clear to Moore that he could not and would not read his novels, which in his view belonged to that category of writing he stigmatised as "gush"[18]. His preferences in Art were consistent. A classicist in gardening he preferred, like his father, the classical in architecture. He regarded St. Paul's Cathedral, the interiors of which he continued to paint for as long as he could put brush to paper, as the greatest building in the world. In literature too he abhorred all romantic emotionalism so that he counselled his sons to prefer the classical restraint of Turgenev's novels to Hardy's.

Windlestone's unique blending of the aristocratic and the aesthetic especially delighted and awed Beerbohm who, though posing as one of his own most exquisite creations, was not at that date yet entirely self-assured. In a letter[19] from Windlestone to Reggie Turner dated 12th January 1898 Beerbohm writes –

> Observe this notepaper. I write from the Stately Home of a Baronet of Jacobite creation, Sir William Eden in the County of Durham. Walter Sickert is here as my sponsor and I have a smoking suit of purple silk with dark red facings – and am rather light headed I am afraid ---- Sir W is a delightful and surprising man. We get on very well together. I sat beside him on the bench at Petty Sessions on Monday wearing my check suit and fancy waistcoat, very bluff but at the same time very intellectual, and with my chin resting on a beautiful white hand. The house is very comfortable and distinguished. In the Hall is a

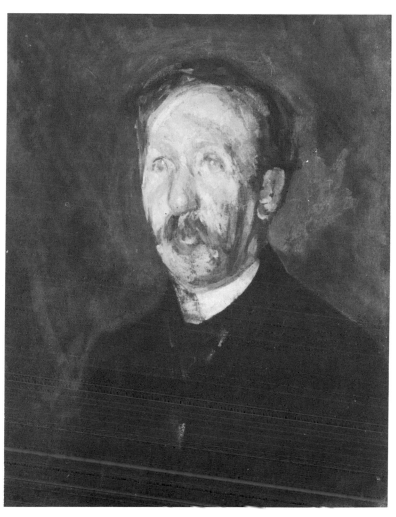

GEORGE MOORE
A Portrait by Walker Sickert

The Tate Gallery

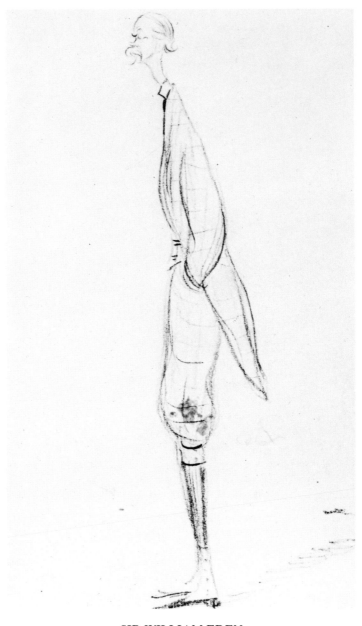

SIR WILLIAM EDEN
By Max Beerbohm

From Max's Nineties by permission of
Sir Rupert Hart-Davis

Visitors' Book over which I spend most of my leisure moments – a Debrett in MS. The dear Ormonds, the dear Londonderrys, the dear Zetlands and many others too numerous and too distinguished for me to mention --- .

VI

To excel in both painting and poetry is dangerous to a reputation in either, as William Bell Scott, Dante Gabriel Rossetti and others have found, such excess of talent being regarded as indicating a lack of high seriousness and respect for Art. Critics are suspicious of those whose work steps out of class and character, unless of course they are members of what is called the "working class". One suspects there are few critics to-day who would not feel the greatest reluctance to concede (whatever the evidence to the contrary) that a man of wealth, title and position in Society, and a renowned sportsman, could also be a serious and distinguished artist.

Sir William, in the course of many years exhibiting at the New English Art Club's exhibitions from 1896 had gradually triumphed over this prejudice, and by the time of his 1911 exhibition at Colnaghi's Bond Street Gallery had long been known and respected by the critics as a watercolourist whose work could be set alongside Steer's and Brabazon's.

Sir Claude Phillips in a review in the Daily Telegraph dated 13th May 1913, of Sir William's exhibition at the Dowdeswell Galleries wrote –

> The Central gallery here now contains a large collection of watercolours by Sir William Eden, comprising English landscapes, country house interiors, a series of studies from the Westminster Cathedral and a few Venetian motives, ------ we have often already spoken of his rare gifts, his sure intuition as a colourist," (Sir Claude then makes a criticism often made also of Whistler in his lifetime reflecting the critics' still continuing unease in the presence of impressionist watercolours). "If he had an equal feeling for the structural elements of a picture, for all that sets it on its legs, to use a rough and ready phrase, and

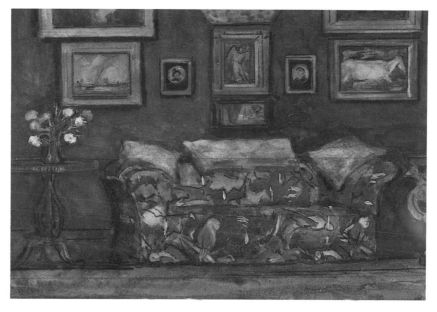

THE EAST SITTING ROOM AT WINDLESTONE
Watercolour by Sir William Eden

By permission of Lady Serena James

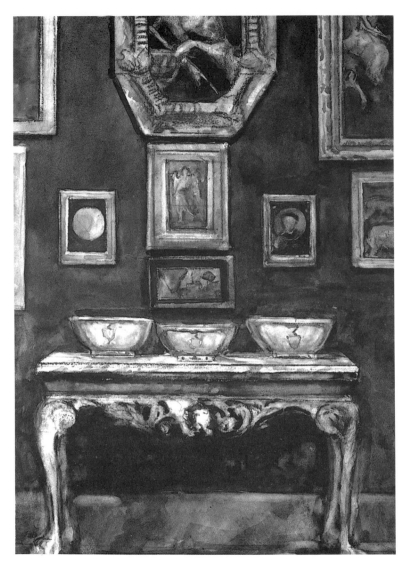

THE MARBLE TABLE AT WINDLESTONE
Watercolour by Sir William Eden

By permission of Lady Serena James

imparts to it the quality of permanence, our appreciation of his attractive work would be greatly increased. However, even as it is, we derive genuine enjoyment from his rich colour fantasies, his nooks in country houses glowing with a tempered splendour, his church interiors seen in a greenish light, the fitful gleam and glance of which resembles that of faintly illumined water.

The watercolours now shown are for the most part painted more broadly --- than those which up to the present Sir William Eden has brought forward. What guides him is just this love of rich, yet always sober and distinguished colour, this power of recognising but also on occasions of inventing combinations both splendid and subtle, as well as paler, clearer harmonies. A sombre splendour that has something of the jewel in it makes interesting such studies as "Japanese Cabinet, Windlestone",[20] "The Redentore, Venice", the chief motive of which is not Palladio's famous church, but a yacht of slight and elegant proportions anchored in the foreground --- is not only a cool refreshing harmony in blue-grey and buff, but a design well placed in space and of unusual decision ---- In the series devoted to Westminster Abbey the colour harmonies – in the one instance, green, azure and lilac, in the other violet, green and turquoise – are of singular truth and beauty.

Plainly this critic understood what Sir William, like Whistler and the New English Art Club, had learnt from the French, – to think of painting in terms of light, colour, mood, tone, harmony and design, and not, as the Academy's devotees thought of it, in terms of story and incident and highly finished detail, or in landscape to which an artificial flourish of "rurality" had been added. It was because of this divide in the art-world that Whistler's Nocturnes and watercolours were said to be "empty" and "devoid of subject matter" – and so they were as those terms had hitherto been understood in England, except for some late examples of Turner, Ruskin and Brabazon. Sir William's work was criticised as "too slight" by those who thirsted for detail as a sign of money well spent.

Whistler's early work (though accepted in France) had been hissed and mocked in England for over thirty years and totally embittered his feelings for England and the English, before his art won a limited acceptance here before his death.

This divide between painters influenced by the French impressionist and post-impressionist school and the world of the Royal Academy, reached its bitterest phase in 1872 when the Academy rejected Whistler's painting of his mother ("The Mother"). The reaction against this academic tyranny was such that painters and lovers of painting began to establish small galleries like the Goupil at 117 Bond Street, The Grosvenor and Dudley Galleries, the Dowdeswell Gallery and several others to show the work of the "new" painters'.

These were the galleries which most often showed the work of Whistler and Sir William, but theirs was never to be an art popular with the Gilbert and Sullivan going public as had been the case with the Victorian realists and the Pre-Raphaelites. There was always, it was thought, something delicately alien and insubstantial about it. Although Sir William was as childishly egocentric as Whistler he always behaved with notable dignity and restraint in public, having a patricians contempt for it, whereas Whistler used the Press or any public platform for the expression of the worst excesses of his spite and anti-English malevolence which the unfeeling mockery of his work had inspired. What the serious non-academic painter had to put up with from the public and the art critics is shown by the paroxysms of rage and derision occasioned by the exhibition *Manet and The Post-Impressionists*, which Roger Fry as late as November 1910 put on at the Grafton Gallery.[21]

A letter from Eric Gill to Sir William Rothenstein said "you have a right to feel superior to M Henri Matisse (who is typical of the show – although Van Gogh is the maddest)." Charles Ricketts wrote, "why talk of the sincerity of all this rubbish?", and Wilfred Scawen Blunt wrote in his diary, (15th November 1910) "The exhibition is either an extremely bad joke or a swindle ---- nothing but that gross puerility which scrawls indecencies on the walls of a privy. The drawing is on the level

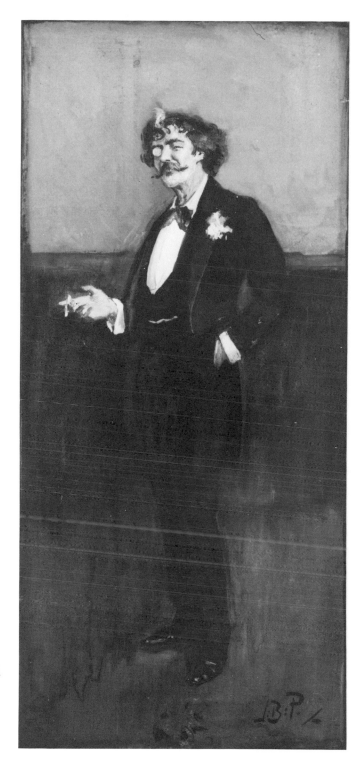

JAMES ABBOTT
McNEILL WHISTLER
by
Bernard Partridge

National Portrait Gallery

THE BARONET AND THE BUTTERFLY
By Max Beerbohm

By permission of Sir Rupert Hart-Davis
From his Catalogue of the Caricatures of Max Beerbohm

of an untaught child of seven or eight years old -- in all the 300 or 400 pictures there was not one worthy of attention – or appealing to any feeling but disgust." Blunt then makes the most monumental monetary miscalculation in all Art History when he writes, "Apart from the frames the whole collection should not be worth £5". The artists who so roused their wrath included Cézanne, Seurat, Matisse Van Gogh, and Gaugin.

Whistler was a painter of genius, vain and polemical, a wit, a calculated publicity seeker and vulgarian, a sensitive and perceptive critic far in advance of his time, and as kindly in private to his wife, his mother and his friends as he was cruel to others in public. Anyone trying to sum him up is faced with the problem that there was not one Whistler but about six, each so unrelated, so separate and contradictory to the others, that they do not seem to be able to be reconciled in the same physical presence. Often impossible to reason or deal with, he so provoked Dégas to say to him "my dear friend, you conduct yourself in life as if you had no talent at all". Dégas further complained, "you cannot talk to him; he throws his cloak around him – and goes off to the photographer".[22] Pursuing his quarrels with Ruskin, Eden, Du Maurier, George Moore and many others, he commented, "One really cannot live in London without a lawyer."

A significant difference in temperament and character between the two adversaries in the Eden v Whistler case (and one much to Sir William's advantage and credit) is the fact that the quarrel between them made no difference to Sir William's admiration for Whistler's work, and he had four Whistlers in his collection at his death, whereas Whistler, merely because he saw a friend walking arm in arm with Sir William in Bond Street between the first and second hearings of the case, returned the friend's card with "Judas Iscariot" written on it; and when the New English Art Club before the end of the case exhibited some of Sir William's watercolours, Whistler said that "they had hung their shame upon their walls", and never forgave them.

Whistler's signature on his work was the "Butterfly" symbol. This "Butterfly" symbol was an imaginative transformation of the pattern made by his initials "J.M.W." It is often suggested that in view of the venom shown by his behaviour a more appropriate symbol would have been a wasp; certainly that would have been a more fitting accompaniment to his gloating account to the Pennells (his future biographers) of the failure of Sir William's sale of watercolours on 15th July 1899 more than two years after the litigation had ended.[23] He seemed, in his spite, to have forgotten his own pain in earlier days when his own work had failed to sell well. This time he did his best to spoil the sale. He was plainly still obsessed by the case and by Sir William.

> Really it has been beautiful – the Baronet's sale to-day – the Butterfly should see how things are going --- I walked into the big room – The auctioneer was crying, "Going! Going! Thirty shillings! Going!" 'Ha! Ha!' I laughed – not loudly, not boisterously – it was very delicately, very neatly done. But the room was electrified --- Twenty shillings, Going! the auctioneer would cry. 'Ha! Ha!', I would laugh and things went for nothing.

What Sir William did not know in 1894 when he had commissioned Whistler to do a small portrait of his wife was that Whistler had expressed in public lectures and in private some very strange ideas indeed about the relationship of painter to client and to the ownership of the work commissioned. One can see that his beliefs influenced his strange conduct towards Sir William in the affair, but Sir William sensibly ignored and refused to comment on the case once he had initiated his civil action in the French courts for the return of Lady Eden's portrait and damages.

It is doubtful if Sir William would have commissioned the portrait without safeguards – however great his admiration for Whistler – had he known that Whistler had publicly expressed his belief that a work of art, when sold "still remained the artist's property, that it was only lent to its owner",[24] and that even when a painting was presented to a friend as a gift, that

gift could be withdrawn and the ownership would revert to the artist once the friend had formed an intention to dispose of it. But Sir William did not know the artist held these strange and twisted ideas, as nonsensical in morality as they were wrong in law.

The origin of the Whistler commission lay in Sir William's pride in the beauty of his wife and his eldest child and only daughter Marjorie. Because he sought reflection of his pride in them, he commissioned portraits from Swan, Von Herkomer, Sargent, Sickert, Wilson Steer, Jacques Emil Blanche, after which dissatisfied in varying degree with the results, he painted them himself. Now in 1894 it was to be Whistler's turn.

Sir William in 1894 had never met Whistler. He wrote to him at the Goupil Gallery and enquired how much he would charge to paint a small head in oils of Lady Sybil. The reply came back "£525". "Too much", said Sir William, and enlisted George Moore as intermediary to obtain a price for a head in watercolour. Whistler replied accepting the commission and ended his letter – "as for the amount, Moore I fancy spoke of one hundred to one hundred and fifty pounds". So the price was not precisely defined and in this lay only the beginning of the mischief.

But without informing Sir William, Whistler changed his mind during the sittings and produced a small oil painting the size of a small watercolour about 12 inches by 8. Whistler never said to Sir William either "the price therefore will now have to be somewhat more", nor even that "at the very least it will have to be the maximum price of £150 already mentioned rather than the minimum of £100". Moreover, whilst Sir William had asked for only "a small head", the little oil emerged as a full length figure of Lady Sybil on a sofa against a background of books. No hint of this was given to Sir William by Whistler. For a man usually so voluble this reticence is hard to understand.

Sir William was going abroad before the painting was finished and visited the studio on St. Valentine's day to pay for

it. Unknown to Whistler he had a cheque for £100 in an envelope and handed the closed envelope to Whistler saying "Here is your Valentine". Whistler did not open the envelope with its cheque and letter of thanks until Sir William had left the studio.

Whistler at once replied –

My dear Sir William,

I have your valentine. You really are magnificent! – and have scored all round.

I can only hope that the little picture will prove even slightly worthy of all of us, and I rely on Lady Eden's amiable promise to let me add the few last touches we know of. She has been so courageous and kind all along in doing her part. With best wishes again for your journey.

> Very Faithfully,
> J. McNeill Whistler.

No doubt it was tactless, thoughtless, and high handed to hand the envelope to Whistler without telling him what was inside and without making some polite enquiry, such as "I presume that is is order?". Yet Whistler's letter is basically a friendly one, the only phrase indicating some irritation being the equivocal "You really are magnificent!" Sir William goes to see him about it, "Well you are" said Whistler avoiding the whole issue in a surprising way for him. Sir William offers to pay him a cheque for £150 if he will tear up the £100 one. Whistler refuses this peace offering. "The time has gone by" he replies. Why on earth has the time gone by – in twenty four hours? Lady Eden writes him, "when shall I come for my last sitting?" She never received a reply. But now comes into being, to muddy the waters, Whistler's strange ideas already referred to as to what is the relationship between painter, client, and the work of art. He does not deliver the painting as he is contractually bound to do, he does not return the £100 cheque as in all morality he must – he keeps the cheque and pays it into his bank account and refuses to give up the painting he has been paid for!

After many fruitless requests from Sir William's solicitors to return the painting, Sir William sues for its return, or his cheque and damages, in the Paris Civil Court. Since it was a civil case it was not possible for either Sir William or Whistler to give evidence, the case having to be decided on letters, documents, legal pleadings and argument by Counsel which robbed the case of most of its drama. Shortly before the hearing began Whistler returned the money paid by Sir William.

What shocked the court was that, when the picture was produced, Whistler had – in accordance with his expressed belief as to his rights – painted out Lady Sybil's face, so that it was a portrait no more. On 6th March 1895 the Court ordered Whistler to return the price of the portrait (which late in the day he had done), to deliver to Sir William the portrait as originally painted, with a penalty to be imposed for any unreasonable delay, and to pay 1000 francs damages. It seemed an impeccable judgment but Whistler appealed to the Cour de Cassation.

On 2nd December 1897 – in a judgment difficult to understand – the Appeal Court decided that Whistler could keep the picture on condition he made it unrecognisable as a portrait of anyone in particular (he had already done that), Sir William was to have his money back (which he already had) plus 5 per cent interest. Whistler was to pay £40 damages to Sir William with interest at 5 per cent. Whistler was to pay the costs of the first trial, and for reasons which were never clear, Sir William was to pay the costs of the appeal. Sir William never even appeared in Court at any stage of the hearings.

Whistler was jubilant and for some reason sought to persuade himself (and others) that he had won a great victory (which he had not); but he had long since parted from all commonsense in his obsession with the case and with Sir William. On 13th May 1899 he published a book on the case called "The Baronet and the Butterfly", and in addition to his Butterfly signature there is the drawing of a toad against which a butterfly darts its sting. The book consists almost entirely of

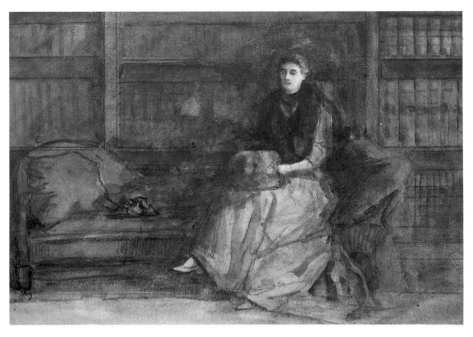

STUDY IN BROWN AND GOLD
This is a portrait of Lady Eden by Sir William Eden after Whistler
had destroyed the original

By permission of Lord Eden of Winton

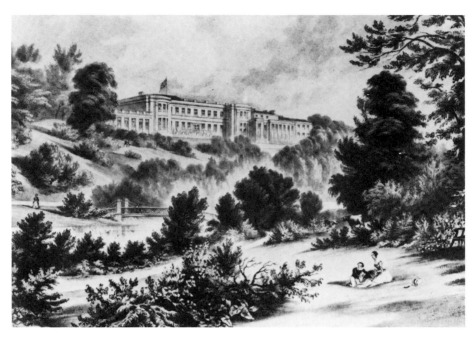

WYNYARD
By J. W. Carmichael

reports of the speeches of advocates and judges. It must be the dullest and silliest book ever made by a painter of genius – I cannot say "written" because there is not very much by Whistler in it.

VIII

If Sir William's family were frightened by his uncertain temper and rages, they realised he was for the most part fond of them, and proud of his wife's beauty and Marjorie's.* To Timothy, Anthony and Nicholas, his "little boys", as he publicly and communally addressed them, he behaved like a Commanding Officer on occasional visits of Inspection, warning them against the dangers of "petticoat rule" and "mollycoddling" by their mother – "Take that muffler off at once dear boy, it will weaken and injure your throat". None of his children can ever remember him being at home for Christmas, the combination of a religious festival and close contact with his children in the same house over several days proving too frightful a prospect to face, and from which he fled to London, to Venice, ---- to anywhere. Marriage with such a man could not help but be stressful, and increasingly so as he aged, but money gives a marriage space, separateness and time, which enables it the better to survive even its worst periods.

Theresa, Lady Castlereagh or Londonderry, (1856-1919) ("Dear Nelly" to both Sir William and Sybil), wife to Charles the 6th Marquis (1852-1915) and daughter of the 19th Earl of Shrewsbury, was a near neighbour and true friend to both of them. Sir William knew he could trust her, wrote accordingly and took a delight in presenting her with many of his best watercolours, not one of which, alas, can be found at Wynyard to-day. His letters[25] to her are a reflection of his declamatory, perceptive, buccaneering and self-justifying self – and curiously endearing.

*She became the Countess of Warwick by marrying Guy Brooke, the son of Daisy, Countess of Warwick, Socialite and Socialist, mistress to King Edward VII for several years and to other men as well, faintly ridiculous and excessively generous, editor of the Memoirs of Joseph Arch, founder of the Agricultural Workers Union. Heir to over £30,000 a year, her benevolence soon reduced this to under £6,000. By her marriage therefore Marjorie acquired as mother-in-law, a character quite as extraordinary as her own father.

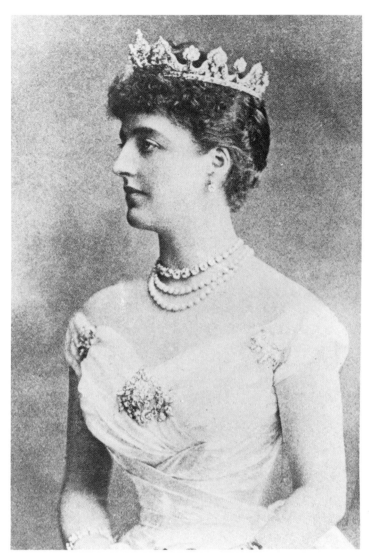

THERESA, LADY LONDONDERRY

From the collection of H. Montgomery Hyde Esq

WYNYARD

Photograph by Ursula Clark

From Dresden he wrote[26] –

. . . . I too have been anxious and worried about Sybil, but she is better though still to be carried up and down stairs – the rest of the family are flourishing and getting stuffed up with German – a detestable language which I shall make no attempt whatever to cope with. This town, like every other in Europe that I know, is fast losing its beauty in these degenerate days – taste is gone – oh but people say you have got tramways and corridor trains I shall I hope be backwards and forwards during the autumn and then I shall with pleasure propose myself to Wynyard. Don't think of answering this but with love.

<div align="right">Yours affectionately,
William Eden.</div>

From 12(B) Waterloo Place, London, he wrote[27] –

Dear Lady C,

By a combination of influence and artifice you have succeeded in getting one of the best Sargent's I know. It is I suppose uncertain yet what pedestal Sargent will occupy eventually but at all events it must be very high. In my opinion he is by far the greatest portrait painter in any country since the great days of the great men – Reynolds and Gainsborough. This picture of Grace reminds me of Frans Hals who was nearly if not quite equal to Rembrandt. The black is marvellous. The only possible criticism I see and that may have been owing to the light, is that the face looks almost *too* brilliant for the surroundings.

Je vous en fais mes compliments. It is a pearl possession ---- ever Yours affectionately,

<div align="right">William Eden.</div>

From Windlestone[28]

> Nothing changes except for the worse especially Art
> Herewith the 'Rose Window'[29] – I hope you like it – it is
> one of my best – many people have tried to buy it, but I am
> glad I kept it to give to Lady Londonderry.

Although the Edens were nothing like as rich as the Londonderry's (and even if coal had been found on the Windlestone estate it is certain that Sir William would have refused to mine it), they were fully their social equals. If the Londonderry's could take pride in their connection with Marlborough and Castlereagh, the Edens were linked with a former Prime Minister through the Northumbrian Greys and had the earlier roots in history. Sir William trusted Theresa and felt free to write on the most painful personal matters knowing that she herself was no stranger to family stress and tragedy.

For Lady Londonderry during her marriage had become the mistress of the Honourable Harry Cust, younger brother of the Earl of Brownlow, a Member of Parliament who at one time was regarded by many as a future Prime Minister. His poetry can be found in the Oxford Book of English Verse and he had many gifts but he wasted his life away, achieving little more than an infinite number of fashionable seductions.

Lady Londonderry had replaced Lady De Grey as Cust's latest victim and in revenge, Lady De Grey sent her footman to deliver to Lord Londonderry certain stolen letters written by Theresa to Cust which contained mocking references to her husband. Lady De Grey's footman delivered the letters to Lord Londonderry who read them and sent them to his wife with a note, "Henceforth we do not speak", and kept his word, say some,[30] save for the few words necessary at public functions, refusing even in 1915 when he lay dying to see or forgive Theresa. If true, such implacable lack of forgiveness for over thirty years is more in keeping with the setting of Italian opera rather than a scene set against the pit heaps of Durham County, although Wynyard, a vast palace begun by Philip Wyatt and finished by Bonomi, the architect of Windlestone, is certainly Italianate enough.

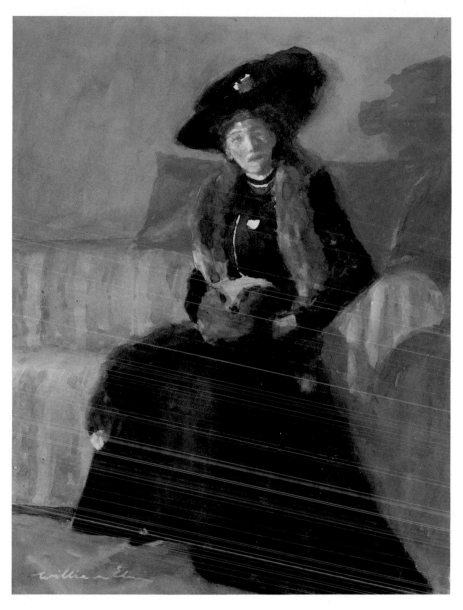

Portrait of The Countess of Scarborough by Sir William Eden
Collection, Lady Serena James

*The following plates are all from watercolours
by Sir William Eden*

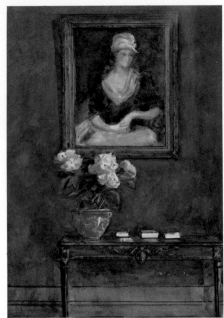

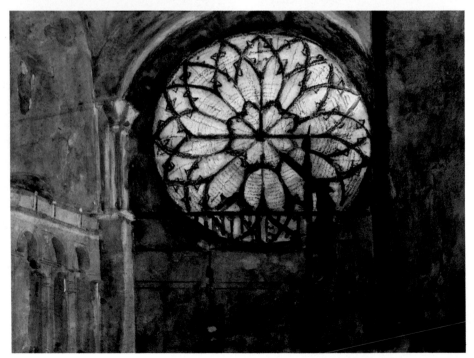

The Japanese Cabinet
at Windlestone

Still Life with Portrait
of a Lady

Collection, Lady Serena James

The Rose Window
Collection, the Countess of Avon

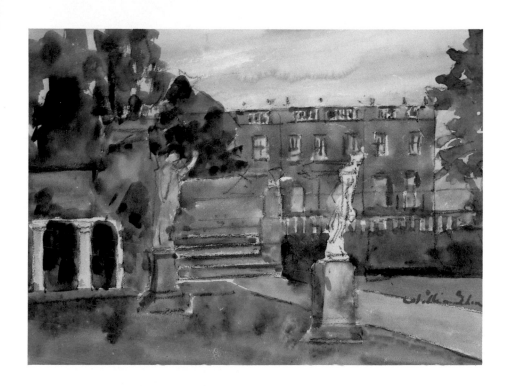

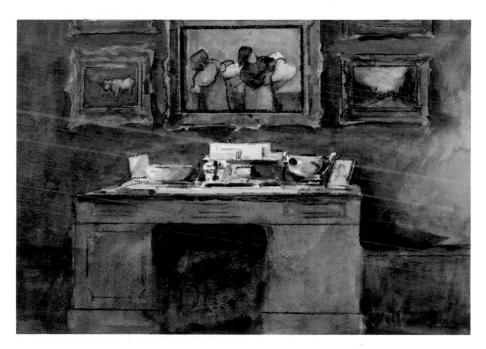

The Garden, Windlestone
Sir William's Desk with Paintings by Mark Fisher, Degas and Corot

Collection, the Earl of Avon

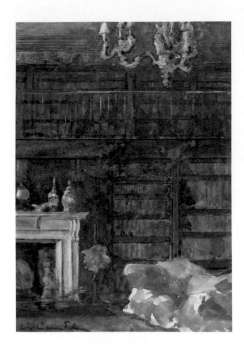

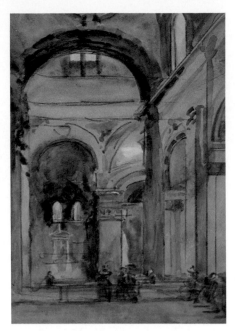

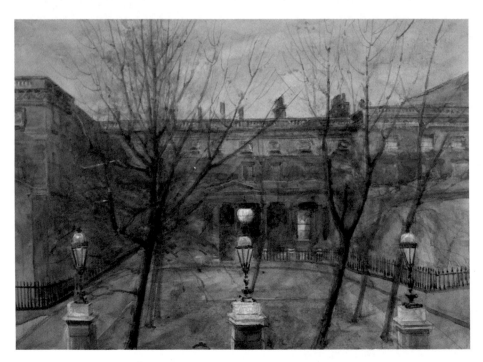

Corner of the Library Windlestone
Collection, the Earl of Avon

St. Paul's Cathedral
Collection, Lord Eden of Winton

The Ambassadors' Entrance, Buckingham Palace

Collection, the Earl of Avon

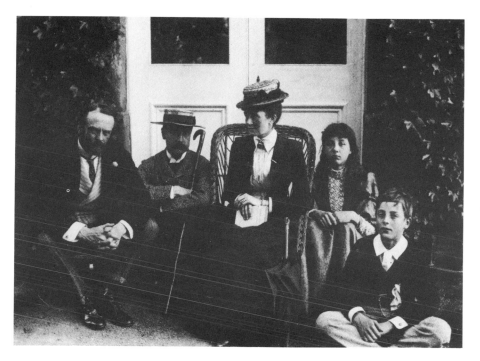

From left to right:
Sir William Eden, Charles, sixth Marquess of Londonderry,
Lady Melgund, Lady Helen Stewart and Lord Castlereagh

From The Londonderry Album, *Blond and Briggs, 1978*

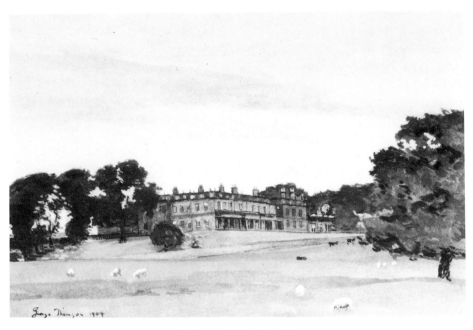

WINDLESTONE, 1904
Watercolour by George Thomson

Collection Lord Eden of Winton

Such a melodramatic story is scarcely supported by Sir
William's easy and relaxed references to Charles in his letters
to Theresa, and he was both a frequent visitor to Wynyard and
a family friend who must have known the true position between
them. Doubtless the affair was painful and led to an uneasy and
wounded separateness in their marriage, but conversation and
consultation still went stiffly on[31] in private as well as on the
great curving staircase of Londonderry House in London where
the Londonderrys jointly, (or slightly separately as some
observers thought), received their guests at their famous
receptions held to mark the beginning of each Parliamentary
Session.

The present 9th Marquess believes[32] that Lady De Grey sent
the incriminating letters to the 6th Marquess not in revenge for
Theresa's undoubted affair with Cust, but in revenge for her
equally undoubted intrigue with Lord Annalby. Although
admitting the damage done to her marriage, he dismisses the
idea of a thirty year unforgiving silence as farfetched. Even the
subsequent birth to Theresa of a child accepted at the time to
be not her husband's (favourite candidates for paternity being
the Prince of Wales and the best man at her wedding, Reginald
Helmsley who had married her sister), did not affect her
pre-eminent position in Society and illustrates once again that
the morality of some of the greatest country houses even during
the last quarter of the nineteenth century was still Regency
rather than Victorian.

By September 1912, Sir William is writing to Theresa about his own family and personal troubles. One of the main causes of dissension were his complaints of his wife's extravagance, by which he meant her charitable work and her gifts of prime cuts of meat costing hundreds of pounds to the tenants and the needy of the district. Because of his own acquisitive collecting and refusal ever to be satisfied with anything but the very best for the estate, (for the big shoots his gamekeepers were dressed in suits of identical tweed made by his London tailor), even he recognised he was not on the strongest ground here. Like so many collectors before him, driven into corners by their wives on expenditure, he sought escape by calling her spending "extravagance" and his own picture-buying "investments".

This dispute over expenditure was also part of a related dispute over his provision for the three youngest boys – Timothy, Anthony and Nicholas. Particularly during the last ten years of his life his wife was constantly urging him to save for their sake – for Jack, his heir, would inherit the estate, Marjorie would marry well, leaving the three younger boys as his most urgent responsibility. To this he would again reply "But I am buying pictures for them".[33]

In a letter to Lady Londonderry he wrote[34] from Windlestone

> ----At the same time I don't like the idea of your being under a false impression about Sybil, and my deter-mination to shut up the house. The extravagance has been more than I can afford and the debts now coming in I never reckoned on ---- I have asked her to live in this side of the house and shut up the rest – she won't – and she is furious with me for bringing about changes to be able to pay her debts ----

It is impossible of course to expect you or Charles (the 6th Marquis) to agree with me about the purchase of pictures, china, plate, etc. – but I know what I am about in that line – I assure you anyhow I prefer to lay out what money I can find in such things as investments rather than spend it on charities, philanthropies, politics and such follies. When I die and my things realise you will see what you shall see ---- Sybil is now at Bexhill with the boys having taken a house there of her own accord quite without rhyme or reason leaving their shooting, their riding and their home! – can't you see?

When he wrote this letter he was 64 years old and not in good health. His tiredness and desperation to be done with quarrels must have been extreme for him to suggest leaving Windlestone, now his only pride and joy, or even to live in a wing of the house.

But there were still good times as well as bad. Within a month of writing this desperate sounding letter he was writing from Windlestone (13th October, 1912) –

"Sybil is here in good form and sends love", and he has obviously enjoyed leading some excessively refined garden visitors from Wynyard down forbidden garden paths. "We were very glad to receive a consignment of visitors from Wynyard – though they were not allowed to stay long! They were all of them 'darlings', They all of them went away swearing they 'loved' my garden and they would all of them go home and plant geraniums and calceolarias!" And he ended the letter – "Take my advice about trees and I will take yours about women ---."

In a later letter[35] to Lady Londonderry written from Venice where doubtless he had gone to escape the children and Christmas, he wrote to the sceptical Theresa who like most of his Durham neighbours regarded his contemporary acquisitions as worthless aberrations –

I estimate[36] my 3 Dégas to be worth anything now between 5 and £10,000.

In the same letter he tries to persuade Lady Londonderry of his own parsimonious and careful way of life. "This is not a Palace but tout simplement un flat! Every house in Venice is a Palace like everyone wears a red ribbon in Paris, and everyone is a Baronet and no one a gentleman in England. Meantime the position in this. I allow Sybil £4,000 a year irrespective of Marjorie and Jack and I take £1,500 tout compris including the upkeep of the house at Windles and in London. How many are there, dear Lady L that would take the opposite course! I am no Saint God knows, and thank God – but my heart's desire is to leave a clean slate before I join my ancestors – and I can't further reduce the estate costs without injury and loss – and I can't curtail my own personal expenses – for I spend *NOTHING!*"

Explaining to Lady Londonderry why he had not recently been to see her, he writes on New Years Day 1913 –

> You will have to come to me. My health is absolutely broken. I am laid low with gout ---- It is amazing how quickly one smashes up! – but you bear witness I was a fairly good man once ---- As the Chinese put it, 'It is better to be a crystal that is broken than a tile on a roof and remain perfect for ever!'

However the letters to Lady Londonderry contain more cheerful things. Writing from Venice in winter. "The weather is just 'good hunting weather', raw and cold and damp and foggy but so much more beautiful than Sunshine. As I tell them, Sargent, Sickert, – Sunshine, and the Salute, have ruined Venice – In this weather it is wonderful – the shipping and gondolas and churches seen through a haze darkly and the interiors lit up with dim religious candles for the retired but immortal souls of the just!" In 1909 he had written her "I am too old to be dissipated but not old enough to give it up!"

In another letter to *The Saturday Review*[37] he writes –

I was in Venice last winter ---- The Salute always seems to me, like the Esterelles, especially made for young ladies to paint. You know the blue and pink of the Esterelles and the eternal sunshine settling on the facade of the Salute. The Salute is decadent and rococo. Only turn and look at the lovely San Giorgio, or the still more beautiful Redentore – Palladio at his best – putting your back against that hideous Custom House. But I will tell you from where the Salute is beautiful – that is the back of it from the Giudecca, relieved with olives, or probably ilex and cypresses – lovely it is all, with the shipping in front, I don't mean with Clara Montalba sails, but without, with the bare rigging beautifully drawn and set in between. I wish they would have cypresses everywhere in Venice, but they tell me there is a superstition against them. All superstitions are foolish, and when they interfere with beauty they are criminal. We know that cypresses would 'do' well, as witness the cemetery on the way to Murano. How well they would shoot up and how quickly they would grow! Whilst in Venice I went to see Danieli's Hotel, thinking to find the remnants of taste that I recollected years ago. Not a bit of it. I was shown over the place by a delighted and proudly gilt manager. I found the gilt and gingerbread to suit, I was told, the modern Americans taste. I was told also that you must keep up the beau ideal of Italian palatial residence --- There was not a chair you could sit in, a bed you could enter or a stick of comfort. But instead a mass of reflecting looking-glasses or mirrors to duplicate the horrors, vulgarity and discord everywhere. And this is what succeeds like success; and the price of the rooms was equal to the gold of the decorations.

The manager was quite disgusted with my remarks ---- An hotel that would be comfortable and inoffensive could be, but won't be, built at Hyde Park Corner. Keep to simplicity, avoid display. Why not build exactly on the lines of Apsley House, or Stafford House, or the garden front of Buckingham Palace? ---

Inside the hotel pray avoid decoration; let distemper, as in the old Italian palaces, be the aim; and dispense with the charms of palms and flowers that cost a lot, and that no-one looks at so long as there are beautiful women, and they are cheaper ----

'Sir', said Dr. Johnson, 'let us take a walk down Fleet Street'. How delightful it must have been then, when people for instance took snuff to no-one's annoyance instead of smoking in your face. But this is beside the question. It is the terrible destruction of beauty, the construction and the reconstruction of the vulgar that is to be deplored but will never be arrested ---- there is nothing to be done; 'things' ---- must take their course.

There is no possibility of influencing anything. For my part I am a fatalist. Good day.

WILLIAM EDEN

During the last years of his life the faithful and often dismissed Woolger was probably the person who most easily shared his mind and thoughts. Woolger witnessed the incident at Windlestone on a Hunt day when although the heavens had opened just before the Meet ("O God, how like you!"), the barometer in the hall showed "Set Fair" and all Sir William's tapping efforts failed to change its mind and message. Seizing the barometer off the wall he flung it from the front entrance down the house steps shouting "Go and see for yourself, you bloody fool".

In 1911 he took a flat at 28 Bury Street, London, "this beautiful lodging of mine", next to Rosa Lewis's Cavendish Hotel, and stayed there with Woolger on his visits to London. Here he painted, wrote letters to pretty young women and articles on art and gardening for the Saturday Review, developing the idea of a garden without flowers.

GARDENS WITHOUT FLOWERS

I have come to the conclusion that it is flowers that ruin a garden, at any rate many gardens. Flowers in a cottage garden, yes. Hollyhocks against a grey wall; orange lilies against a white one; white lilies against a mass of green; aubretia and arabis and thrift to edge your walks; delphiniums against a yew hedge and lavender anywhere. But the delight in colour, as people say, in large gardens is the offensive thing: flowers combined with shrubs and trees! The gardens of the Riviera for instance; Cannes and the much-praised vulgar Monte Carlo – beds of begonias, cinerarias at the foot of a palm the terrible crimson rambler trailing around its trunk. I have never seen a garden of taste in France. Go to Italy, go to Tivoli, and then you will see what I mean by the beauty of a garden without flowers: yews, cypress, statues, steps, fountains – sombre, dignified, restful. And as every picture should have a bit of distance to let the eye out of it, here and there you get a peep at the hills. Distant beauty in a glimpse, given in a setting, a bit at a time. And you may add, if you like, a moving figure; 'an Eve in this Eden of ruling grace'.

Above this, as you look up, you recollect, is the Villa d'Este; classic – the garden and the architecture suited the one to the other. How I remember the noble stone pines in the Borghese at Rome, the sad and reticent cypress in the Boboli Gardens at Florence, round about the fountains! What depth and dignity of background! A place to wander in and be free.

After all, the suitability of things is what is admirable. Are they 'in Value', as artists say? The relation of tones correct? They do not swear? A woman suitably dressed, a man properly mounted, a picture well framed. People talk of colour; 'I like a bit of colour in this cold and gloomy climate', they say. Agreed: but what is colour and where? Titian was a colourist, but always low in tone. Put a yellow viola beside the brightest tints on Titian and you will see.

Keep your effects subdued. Never mix reds or pinks and yellow; put yellow and orange and green and white together; put blues and mauves and greys together; and let your backgrounds be broad neutral, plain. If you have a herbaceous border against a wall, let the creepers on that wall be without flowers or nearly so. Let the wall be the background to frame it. You would not hang a Tintoretto on a Gobelin tapestried wall.

Have you ever been to Penshurst? There again is the beauty of a garden without flowers. It may have been accident, it may have been the time of year that made me like it so. There is an orchard and yew hedges and Irish yews and grass paths. And there is a tank with lovely pink brick edges and sides, and water lilies and fish; and it is surrounded by a yew hedge and grass paths, and its four corners have steps down to the wall, and a ball on each pedestal at its base. And the apple blossom peeps over the hedge, and the raw sienna of the lichen everywhere on the stone gives the richness of gold: and that's all there is in the colour scheme. The only flowers I noticed were patches, unrestrained and unplanned, of auriculas, evidently from seed – all colours; many fringed with margins of gold, like the eyes of la fille aux yeux d'or in Balzac's novel. All else was richness, depth and calm, abstract but clearly felt.

Against this of course there is the garden of the Manor House, the wealth and luxuriance that is the result of the soil that suits and the flowers that dwell so happily against the grey old walls. There you can scarce go wrong – campanulas, foxgloves, endless lists of things. Flagged courtyards, flagged paths, sun-dials – you know it all. And if you can find a place with a moat, a clump of yews and a king-fisher, stay there if you can.

Never have flowers against a balustrade, only grass or gravel. Begonias, geraniums, calceolarias are hard to manage anywhere. Annuals are delightful, but their reign is short. Try nemophila called discoidalis, dull rather in colour, as they say, and like auriculas more or less.

Linaria, too, you know, a very useful purple. It goes well with gypsophila.

You must have noticed that many flowers most beautiful cut are impossible grown in beds. Carnations, for instance, roses and sweetpeas. You take your lady down to dinner. She is fond of flowers. She knows what she likes and she admires the decorations. They are certain to be either sweetpeas and gypsophila or smilax and malmaisons. You try to make way amongst the smilax for her knick-knacks – her fan, her gloves, her scent, her powder puff, her matches and cigarettes. Eventually she puts half of them on her lap, and you have to get them from the floor after dinner – which you hate and she is more amused at your annoyance than grateful for your trouble. Such is her sense of humour and her manners.

Fruit is the proper decoration for the dinner table, not flowers. I am sure the Greeks only had fruit. Orchardson in that picture of 'The Young Duke', I think it is, has fruit only in the wonderfully painted accessories of the dinner table. The Dukes are all alike, but the fruit and plate are not. But all fruit is not beautiful. Oranges and bananas, for instance, are not. Grapes, apples, pears and pineapples are. What is more beautiful than black grapes with the bloom on them in a silver or gold dish?

X

By knocking down a wall of his flat which was shared with the Cavendish, Sir William turned his flat into an annexe of the Cavendish Hotel with his own private entrance. He was looked after well by Woolger and Rosa Lewis who plays her part in almost the last of the Baronet's many tragi-comical relationships. Sometimes Lady Eden came down to stay with him although the rakish[38] Regency atmosphere of the place was more to his taste than her's.

His extraordinary letters to Rosa Lewis drew forth equally extraordinary replies.

Mrs Lewis – Charming Woman!
Will you please turn out that damned dog before I have to murder it or you – you for choice.
<div align="right">Yours in ever increasing affection,
Sir William</div>

She would often begin her equally rude reply "Dear Sir William, BART" or sarcastically end them by signing herself "Rosa Lewis, BART". She not only kept alive his capacity for abuse and enmity, provided him with the best food in London, but in 1912 allowed him also to stage a boxing match in the dining room between Bombardier Wells and Sid Smith to which he invited not only his noble friends but all the porters and staff in the hotel. His letter warning Rosa of his plans read:-

Dear Mrs Lewis,
I am coming up crowned in glory on Tuesday. The Hon. Ashley too. Now look you 'ere. I shall have a dinner party that night – noblemen, gentlemen, women, bookies, and prize-fighters and we will box in the dining room after. See? Tell your Lord Ribblesdale I want him, dinner and after, and anyone else you may think of – pretty – either sex – none but the brave deserve the fair.
<div align="right">W.E.</div>

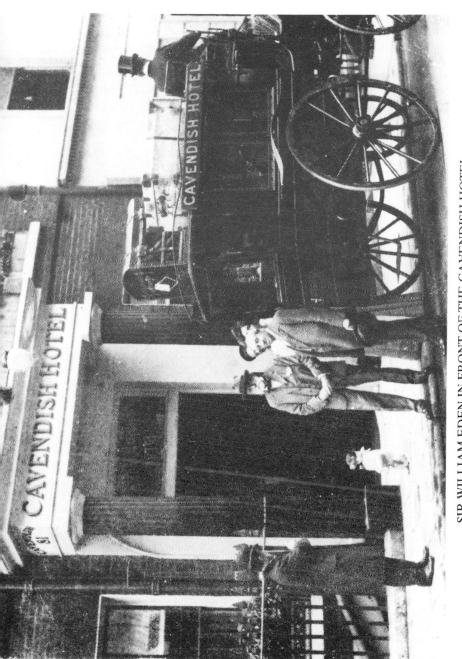

SIR WILLIAM EDEN IN FRONT OF THE CAVENDISH HOTEL
WITH ROSA

By permission of the Hon. Daphne Fielding

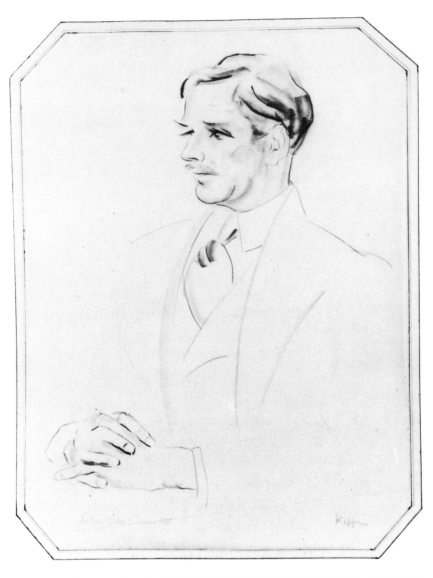

MR ANTHONY EDEN, LATER TO BECOME THE FIRST EARL OF AVON
by Xavier Knapp

National Portrait Gallery, London

By 1913 he is quarrelling not only with his wife, when she is with him, but with his eldest son over money and marriage. The other children avoid him. He feels himself abominably deserted and alone. And the world is becoming even uglier. "In London he dances round some new offence, some spick and span pretentious monstrosity, cursing and shaking his stick at it, vilifying at the top of his voice the Government, the County Council, whoever is responsible, wishing he could have the architect by the throat; and the people passing by move off the pavement to avoid him and look at him with amazement, a big strange picturesque figure, with top hat, fluffed hair and purple cheeks, vicuna trousers and a plum tie in a careless bow."[39] What would he have felt and said today of the concrete tower blocks, the skyscrapers dominating his beloved St. Paul's, the bright new squalor of modern architecture and the new centres of our cities ugly beyond his most farfetched nightmares? He was at least spared that but found even the incipient ugliness of his own day insupportable.

> Dear Sir,
> I have seen announced in a delighted oh-be joyful sort of spirit, the prospect of the destruction of St. Georges Hospital with the subsequent erection of a mammoth hotel. One can imagine the sort of American skyscraper from the atrocities that have been committed lately. 'The progress of London', indeed. Let us hope the interesting pot-house will some time blow up. A 'pleasure city', some say. What an abomination of vulgarity this represents! Hyde Park Corner, as it is, is beautiful and picturesque if you bar the two statues of the two angels on horseback. ---- Angels on horseback are good at dinner but nowhere else – Let us have a committee to select the plans – not of titled artists or architects without taste, but someone else – myself for choice".[40]

> Yours truly,
> WILLIAM EDEN

He returns to the subject of angels in sculpture in another letter[41] aroused by discussion of the proposed memorial to King Edward VII. "Surely we are satiated with memorials crowned by angels. And why angels? There is only one beautiful angel in sculpture at any rate that I know of, and that is the Nike of Samothrace in the Louvre. These modern angels, with their laurels and their palms and their offensive, domineering superior attitude are dreadful people.

"A friend of mine who is also an artist, told me that the reason why angels are always a failure in art is that they are taken from women, and no woman can ever be an angel. A griffin on the other hand, is quite a better affair. I can think of no-one even in history wicked enough to deserve the penalty of an in memoriam angel – much less should it be placed on a monument to record the merits of our good King Edward."

During the fine late autumn of 1914 he is at Windlestone but he is now under morphia and can only move around his beloved gardens pushed by Woolger in a wheelchair. He tries to paint in the garden but his morphia-ridden body can only produce a meaningless blodge, and he gives up his brushes to Woolger. He tries to shoot but cannot aim correctly and he surrenders up his guns to Anthony. In October 1914 news is brought by a friend to him at Windlestone that his eldest son Jack with whom he had quarrelled the most bitterly of all his family had been killed.* He moves to Duke Street with instructions that only Woolger was to be at his bedside when he died.

It was doubtless about this time that the last entry in his notebook was made. "For now the incarnation of my destiny is nigh. The worm of the world has eaten out my heart".

It is at this point, as Sir William's life draws to its close, that we have to face up to Sir Timothy's question in *Tribulations of*

*He was spared the knowledge that in 1916 his youngest son, Nicholas, at the age of 16, as a midshipman, was to go down with his ship at the Battle of Jutland. The Edens have paid a high price for their bravery. They forfeited their estates under Cromwell, and Sir William's father might not have succeeded to the Windlestone estate had it not been for the death in action at New Orleans in 1814 of another 16 year old Eden. In the first World War Sir Anthony lost two brothers, was himself decorated, and in the second World War his elder son Simon was killed flying with the R.A.F.

a Baronet, – "why it was that the life of William Eden in comparison with its great possibilities must be regarded as a failure --- and to speculate on the causes of the hopeless embitterment of a nature gifted with so many and so varied talents for success". I would go further and ask – "why did this man who did everything to which he put his hand superbly well, from horse racing to painting, from dispensing justice at Sessions to estate management, from soldiering to gardening, from hunting to aesthetics, never win the opportunity to make a greater mark on his age and on his fellow-men, even though he was pleased from time to time to know that around the dinner tables of his friends he was often talked of as the cleverest man in England? Why was such a man, in old age, reduced to finding relief from his frustrations by writing spluttering letters of rage to the newspapers?"

The answers, if not simple, are not too difficult to find; namely that he had too low a threshold of disgust for the age in which he lived – and perhaps for any age; that he never lost a childish attachment to and veneration for the truth, and could feel only a bewildered loathing for those whose speech and feelings were false. Most of us as we grow older are able to mask such feelings or are trained by life to know that if we do not, it will go ill with us – but not so with Sir William. He never learnt that truth may be many-sided and that, in any event, the world cannot stand an excess of it. What disgust with his own times, so vehemently expressed, left of reputation, his own rages finally destroyed.

This made him, unlike so many Edens before and after him, unfitted for Parliamentary or indeed any public life beyond the parochial one of the Squire which role he filled to perfection. Towards the end, his angry letters to the Press on the depredations of dogs, tobacco, Americans and on aesthetics and architecture, are the angry explosions of a man who realised that, except for his gifts as a painter, his impatience, his temperament, his intolerance with the humbug of the world, had denied him the audience and influence won by lesser men.

On 20th February 1915 at the age of 66 Sir William died in his Duke Street flat. Woolger was with him. He was interred not in the classical mausoleum his father had built, but by his express wish was buried in the earth of the Windlestone he had made beautiful.[40A] The pictures he had collected were sold at Christie's on 1st March 1918 and included amongst many others 24 Brabazons, 3 Dégas, 2 Corots, 12 Sickerts, 1 Turner and 4 Whistlers and realised a total of just over twelve thousand pounds.

As for the estate itself, the years from 1910 had seen it in its last autumn richness. Perfection still reigned in the gardens and greenhouses although guests were fewer and the house was for periods without its family as Sir William spent longer periods in London and abroad, and Lady Eden took the boys south during the holidays from Eton. Even as late as 1907 it was written of Sir William. "He has been able by purchases from Lord Eldon, close at home, to consolidate and increase the estate". But this impression of growing prosperity was an illusion – "an extravagant desire for perfection in house and garden had exacted its toll and a life devoted to satisfying an artist's passionate desire for colour, beautiful possessions and artistic experience --- combined with the exactions of death duties made Windlestone after his death --- only a precarious shadow of its former glory".[43] Lady Eden lived on until 1945 in a smaller house on what had been part of the Windlestone estate, still dispensing the charity which had so enraged Sir William and which had made her so well beloved.

SIR TIMOTHY EDEN

Library of Associated Newspapers

SIR WILLIAM EDEN
A photograph by the sculptor Prince Paul Troubetzkoy

Timothy succeeded Sir William at the age of twenty two, and rarely if ever has a talented son, as the years pass, seem to grow into a more controlled version of a talented and temperamental father. His strongest talent was literary. Anyone who could write "The Tribulations of a Baronet" (he was forty when he wrote it), is assured of a permanent place in literature. Indeed, as a detailed and sympathetic study of tortured near-genius it is unrivalled this century. But like his father he had a dual talent; whereas his father was a painter who gardened, Timothy was a writer who painted. Both were consumed by an angry passion to protest at the beauty fast disappearing from the world under industrial blight, and were reduced to angry despair by the despoliation around them.

We can see, in the light of what was to happen, there was more to Sir William's rejection of the aesthetic and political optimism of his age than was then generally believed; and Sir Timothy's disillusion in his turn was scarcely less total. Both believed that the credulity of the sophisticated in their own day was little less remarkable than the superstitions of the savage; both believed that the more egalitarian their society became, the worse its art and architecture was bound to be; both were equally out of step with the spirit of their own times, but looking at our society to-day who can say they were wrong?

In Sir Timothy's remarkable two volume portrait of Durham County[44] he writes of the ancient town of Hartlepool with its forest that gave protection to the wild hart that gave it its name --- "an isolated little community of fishermen who were remarkable for their strange dress, their primitive ignorance and their courteous manners. And then, with a pounce and a roar, this forgotten relic of the Middle Ages, this little walled fishing port twelve hundred years old, is seized and devoured in

the whirl of Victorian Industry; a huge modern fungus spouts forth overnight from its hoary medieval sides, and its ancient walls and buildings are smashed, engulfed, trodden under, swallowed up by an epidemic of tawdry houses and streets ---- The only borough in the county to receive its charter from the King of England, instead of from the Bishop of Durham, has become a large commercial town in which, with the exception of the church there is not a single building or street which possesses the slightest architectural dignity".

And Gateshead --- "continues in its pitiful ugliness ---- But Gateshead was not always sad. It has sung its song and rung its bells. It was a little town of windmills – eleven of them sailing together on the hills – with its people living scattered amongst oak-trees hard by a garden of safflowers.[45] Under these trees Wesley preached ---. The name of Oakwellgate remains to remind us of these days, but not a single windmill or a single tree or a single flower is left".

Of Durham Cathedral and City he writes, "They constructed Durham Cathedral, but they failed to construct a drain; not so much because they would have been incapable of doing so, had they set their minds to it, but because they were indifferent to the desirability of sanitation, as we are indifferent to the social significance of beauty ---- To-day the city presents a curious contrast of magnificence and dreariness ----- It possesses in the Bailey one of the most beautiful Georgian streets in England, looking in the half-light of evening with its rare lamps lit like an eighteenth century Utrillo ---- but the river itself is now black with the pollutions of industry --- whilst from the ruins of the old "Hospital" itself --- an uninterrupted view is obtained of a revolting iron gas balloon and depressing rows of ugly slate roofs. Over all the town ------ there hangs a sort of blight difficult to describe but impossible not to feel ---".

From the eighteenth century watercolour Georgian villages like Staindrop, to the wilderness of the Pennines at Cronkley Fell or Rookhope, the contrast is drawn with a painter's eye, and in its angry regret topography and local history become literature. "You reach Cauldron Snout, at a height of 1400 feet

after a long walk over lovely springy turf --- it is the wilder, the more remote of the two cascades; not a single waterfall, but a series of them, one after another ---. High Force, in more sophisticated surroundings at the foot of a wood of fine larches ----- is a sheer fall over the banisters, the most headlong fall in England. In spite of the somewhat Teutonised picturesqueness of its surroundings, this is no pretty watercolour waterfall – as it has so often been represented – but strong and fit for oils: the water, chrome yellow mixed with cream as it falls, and lying in a great pool of Mars red at the bottom; the rocks a greyish red at the top and a dark purple half-way down". It is the painter who writes this with a passionate aestheticism worthy of the father.

Although Sir Timothy's oil paintings never achieved the critical acclaim of Sir William's watercolours, his one man show of 36 oil paintings in Bond Street at Tooth's Gallery in 1936 was respectfully reviewed, the Times stating, "As a whole the exhibition which contained a portrait of Mr Anthony Eden, painted in 1919, and also a self-portrait of the artist, suggested artistic excitement and the direct expression of natural talent rather than professional skill. The paintings were imaginative and characteristic, and somewhat agitated in feeling, with an inclination towards uncanny subjects". Over the years his paintings made their appearance, in mixed shows in London and Paris.

Sir Timothy died on 13th May 1963 at his home in the New Forest, having in 1935 sold the Windlestone estate.[46]

One can imagine Anthony listening to Timothy with a smile and saying "things are surely not as bad as that". For Anthony, with the exception of Suez at the end, had been a middle of the road man all his life. There was nothing remotely middle of the road about Sir William or Sir Timothy. Anthony and Timothy, as we have seen, were descended through their mother from Whig and moderate Reformers; and nothing enraged Sir William more than moderate opinion, whether reforming or not. When he sensed that his family were not in sympathy with any strongly expressed view on any topic, he would round on them and say the worst thing he could – "you are nothing but a bunch of damn Greys!"

Sir Anthony's life lies outside the scope of this work, for by whatever obsessions politicians are possessed they are not usually aesthetic. Yet there are some strange similarities. At Oxford he read Persian, Oriental Languages and Arabic and was more of an aesthete than a politician, founding the Uffizi Society for the study of Italian Art. Like Sir Timothy he wrote a minor classic that will live,[47] "Another World", a vivid description of his early life at Windlestone and an account of some of the worst fighting in the 1st World War as seen by a young officer in the trenches who won the Military Cross and was a Brigade Major at twenty.

He was, as his father had been, a knowledgeable and perceptive collector of modern paintings, from Monet and Braque to the drawings of Dégas.[48] He was a Trustee of the National Gallery for 14 years.

But he seems to have inherited more from his father than a love of Dégas; and after a life spent in painstaking conciliation and careful compromise in Foreign Affairs as a middle of the road Grey, with age and ill health stealing upon him as the crisis of

Suez approached, his exasperation at the disastrous outcome of a long love affair with the Arab World boiled over in rages which those who had known Sir William would have recognised at once; and Anthony, haunted by memories of the drift towards two world wars that had been met only with inaction, behaved then exactly as Sir William might have behaved had he been Prime Minister.

POSTSCRIPT

Turning left through the gates of Windlestone off the road to Bishop Auckland half a mile from Rushyford, it is as if the God Sir William had so often mocked has taken revenge. The exquisite Lodge at the entrance with its Temple front has been deformed by a cement slab extention of hideous colour and shape, justifying all Sir William's fears of what bureaucracy can do. The great Bonomi house is still there, but it looks out not over a lake but over a greenish swamp. The urns have gone from the roof-high balustrade. Nissen huts abound. The classical Mausoleum has been demolished. The interior of the house, now a school, full of life in term time, has lost much of its grace. Of the gardens over which he enthused and raged, and which were once said to contain as many gardeners as flowers, not a trace remains.

And yet who can say that his turbulent life was all to no avail? Does he not have his memorial, even today, in the two fine word-portraits written by his only surviving sons? In the quality and sensitivity of his watercolours? And in the many examples that men still like to recall, of his eccentricity, of his no-nonsense dispensing of justice – and of his reckless debunking of all that was pompous, vulgar and false?

NOTES

(1) *Without the Passion of Love,* by Osbert Wyndham Hewett (The Listener, 23rd January, 1958).

(2) AUGUSTUS HARE who visited Sir Walter at Wallington on 24th September, 1862, wrote in *The Story of my Life* – "Sir Walter has never been known to laugh -- is a strange looking being with an old careless dress. He has the reputation of being a miser his conversations so curious that I follow him about everywhere and take notes under his nose which he does not seem to mind in the least, but only says something more quaint and astonishing the next minute".

(3) p.22 *The Tribulations of a Baronet* by Timothy Eden published by MacMillan in 1933.

(4) Timothy Eden p.114.

(5) Timothy Eden p.102–103.

(6) Letter in Saturday Review, 8th October, 1913.

(7) Timothy Eden p.167.

(8) See DNB Vol. XVI p.356.

(9) In *Das Kapital.* (DNB Vol. XVI p.359).

(10) His work was the subject of an exhibition in the Gerald M. Norman Gallery in Duke Street, London, in 1979.

(11) *The Letters of Richard Ford 1799–1858* published by John Murray 1905 at pp.76–77.

(12) *Another World* by Anthony Eden, p.17, Allen Lane, 1976.

(13) Ibid p.16.

(14) Timothy Eden p.80.

(15) Timothy Eden p.142.

(16) Moore's dedication to his book *Modern Painting* (1893) read –
"TO SIR WILLIAM EDEN, BART
Of all my books this is the one you like best; its subject has been the subject of nearly all our conversations in the past, and I suppose will be the subject of many conversations in the future; so looking back and forward I dedicate this book to you. G.M."

(17) Saturday Review 12th December, 1894.

(18) *Life of George Moore* by Joseph Hone pp.191–192.

(19) *Letters to Reggie Turner*, edited by Rupert Hart Davis, Rupert Hart Davis 1964, quoted at pp.127–128.

[20] It is though that this is the watercolour illustrated in this book at page 50.
[21] *Roger Fry, a Biography* by Virginia Woolf, Hogarth Press 1940, pp.154–159.
[22] *Memories of Dégas* by George Moore, the Burlington Magazine, January 1918.
[23] *The Life of James McNeill Whistler* by E. R. and J. Pennell, Heinemann, 1908 p.212.
[24] *Ibid* p.128.
[25] From the Londonderry papers in the Durham County Archivist's Office.
[26] 28th July, 1903.
[27] 11th July, 1909.
[28] 31st March, 1911.
[29] 17th September, 1912.
[30] *Edwardians in Love*, by Doris Leslie, Hutchinson, 1972.
[31] In *The Londonderrys*, by H. Montgomery, Hyde, Hamish Hamilton 1979 this less melodramatic version is preferred.
[32] See his Introduction to *The Londerry Album*, Blond & Briggs, 1978.
[33] *Another World* by Anthony Eden, p.14.
[34] Letter dated 17th September, 1912 from the Londonderry papers in the Durham Record Office.
[35] Letter dated 30th December, 1912 from the Londonderry papers.
[36] In fact when sold at Christie's on 1st March 1918, too near their date of purchase, they fetched £2,300 and £2,000 and £714 respectively.
[37] Saturday Review 9th August, 1913.
[38] *The Duchess of Jermyn Street*, by Daphne Fielding p.64, Eyre and Spottiswood 1964.
[39] Timothy Eden p.149.
[40] Letter to Saturday Review, 14th April, 1913.
[41] Letter to Saturday Review, 9th April, 1912.
[42] Because the remaining structure of the Chapel at Windlestone had become too precarious, Lord Eden, on 10th December, 1984, as head of the family transferred to the security of the churchyard at St. Helen Auckland, the remains of eleven members of the Eden family, spread over three generations including those of Sir William and his wife.
[43] *Descriptive Account of the Village and Parish of Coundon with a short history of the Eden Family* by J. H. Walker, and *Some Historical Notes on the Eden Family*, 1907 (anonymous).
[44] Published by Robert Hale in 1952 in the County Books series.

[45] Grown for the dyeworks.

[46] He was succeeded by his only son John who had been since 1954 MP for Bournemouth West, thus continuing the Eden association with Bournemouth. It was to Bournemouth that the widow of the 6th Baronet had retired bewailing that Windlestone was her home no longer. After holding several Government appointments Sir John on his retirement from the Commons in 1983 was created a Peer like so many other members of his family before him.

[47] Published by Allen Lane in 1976.

[48] See the article by Deny Sutton "A Stateman's Collection", in Apollo Magazine of June 1969.